DSLR PHOTOGRAPHY FOR BEGINNERS

A Beginner's Guide to Learning About Your DSLR Camera, Lens, Filters and More

Text Copyright © Lightbulb Publishing

All rights reserved. No part of this guide may be reproduced in any form without permission in writing from the publisher except in the case of brief quotations embodied in critical articles or reviews.

Legal & Disclaimer

The information contained in this book and its contents is not designed to replace or take the place of any form of medical or professional advice; and is not meant to replace the need for independent medical, financial, legal or other professional advice or services, as may be required. The content and information in this book has been provided for educational and entertainment purposes only.

The content and information contained in this book has been compiled from sources deemed reliable, and it is accurate to the best of the Author's knowledge, information, and belief. However, the Author cannot guarantee its accuracy and validity and cannot be held liable for any errors and/or omissions. Further, changes are periodically made to this book as and when needed. Where appropriate and/or necessary, you must consult a professional (including but not limited to your doctor, attorney, financial advisor or such other professional advisor) before using any of the suggested remedies, techniques, or information in this book.

Upon using the contents and information contained in this book, you agree to hold harmless the Author from and against any damages, costs, and expenses, including any legal fees potentially resulting from the application of any of the information provided by this book. This disclaimer applies to any loss, damages or injury caused by the use and application, whether directly or indirectly, of any advice or information presented, whether for breach of contract, tort, negligence, personal injury, criminal intent, or under any other cause of action.

You agree to accept all risks of using the information presented in this book.

You agree that by continuing to read this book, where appropriate and/or necessary, you shall consult a professional (including but not limited to your doctor, attorney, or financial advisor or such other advisor as needed) before using any of the suggested remedies, techniques, or information in this book.

Table of Contents

Chapter 1: Introduction to DSLR Photography 1

Chapter 2: How to Choose the right DSLR Camera for YOU- Different Types of Cameras ... 3

 1. What is your budget? .. 3

 2. What will you use it for? ... 4

 3. Are there any other camera and lens options in that system? 5

 4. Do you plan on taking video as well as stills? 5

 5. What other features do you want? 5

What about DSLR bundles? .. 7

Which DSLR is right for YOU? ... 7

 Canon EOS 400D (Digital Rebel Xti) 7

 Nikon D3400 .. 8

 Pentax K-70 .. 8

 Canon EOS Rebel T6i (Called Canon EOS 750D outside the US) ... 8

 Olympus OM-D E-M10 Mark iii ... 9

 Nikon D5600 .. 9

 Canon Rebel SL2 ... 9

 Pentax K-S2 .. 10

Sony Alpha A68 .. 10

Canon EOS Rebel T7i ... 11

Chapter 3: Camera Overview .. 13

The DSLR Camera Mode Dial ... 13

(P) Program Mode .. 14

(Tv) or (S) The Shutter-Priority Mode 14

(AV) or (A) Aperture-Priority Mode 15

(M) Manual Mode .. 16

What about the other pretty symbols on the camera mode dial? ... 17

The Shutter Button .. 18

Red Eye Reduction/Self Timer Lamp 18

Lens Mount .. 19

Lens Mount Index .. 20

Lens Release Button .. 20

Eye Cup .. 21

Viewfinder Eye Piece ... 21

Menu Button .. 22

Playback Button ... 22

Access Lamp-Set Button/Multi-Controller 23

ISO Speed Setting Button ... 23

Focus Point Selection Button ... 24

Display Button ... 24

Live View Shooting/Movie Shooting Switch 25

Erase Button .. 26

Dioptric Adjustment Knob .. 26

Shots Remaining ... 27

ISO Speed .. 27

Aperture Value .. 27

Focus Mode Switch .. 28

Speaker ... 28

Hot Shoe .. 29

Flash Button .. 29

Main Dial ... 30

Zoom Ring ... 30

Focus Ring ... 31

Remote Control Terminal .. 31

Card Slot, Battery Compartment, and Tripod **Socket** 32

 1. Battery Compartment .. 32

 2. Card Slot ... 32

 3. Tripod Socket ... 33

Chapter 4: Types of Lenses .. 35

 Standard Lens ... 35

 Prime Lens ... 36

 Wide-Angle Lens ... 36

 Zoom Lens ... 36

 Telephoto Lens .. 37

 Fish-Eye Lens .. 37

 Macro Lens .. 37

Chapter 5: Camera Filters ... 39

 Types of Lens Filters ... 40

 Circular Screw-On Filters ... 40

 Square Filters ... 40

 Rectangular Filters .. 40

 Drop-In Filters .. 41

 Specific Filters Explained ... 41

 UV/Clear/Haze Filters ... 41

 Neutral Density Filters .. 42

 Polarizing Filters .. 42

 ND Graduated Filters .. 43

What are the differences between ND Graduated and Neutral Density Filters? ... 43

Chapter 6: Taking a Photograph ... 45

 ***Learn to hold Camera correctly 45

 ***Learn the Exposure Triangle 46

 Aperture .. 46

 ISO .. 47

 Shutter Speed ... 47

 ***A Wide Aperture ... 48

 ***A Narrow Aperture .. 49

 ***Worried About Using A High Iso? 50

 ***Learn How to Use the White Balance 50

 ***The Histogram .. 51

 Using Your Camera's Built-In Flash 52

 Understanding the "Rule Of Thirds" 53

 Using a Tripod ... 54

 Get Things into Perspective .. 55

 What's In a Background? .. 55

 Portrait Photography: Keep Eyes In Focus 56

The Great Outdoors: Shoot In the Early Morning and Evening ... 57

When You Feel More Confident: Start Shooting Raw 57

Chapter 7: Storing Your Photographs ... 59

Image Backup Tips for Beginners .. 61

Chapter 8: Editing Your Photographs ... 63

Adobe Photoshop .. 64

Lightroom ... 64

Photoshop Elements ... 65

Corel Paintshop Pro ... 66

Affinity Photo .. 66

GIMP ... 67

Chapter 9: Conclusion .. 69

Chapter 1: Introduction to DSLR Photography

After doing a load of research, you've just rushed out and bought yourself a brand new DSLR camera. You excitedly but nervously unwrap this new baby and are shocked to discover it has more dials and buttons than a retro 1960-1980s vintage phone and the manual is as thick as a Bible! This cool camera will make you look like a professional in front of your friends, but how does it work?

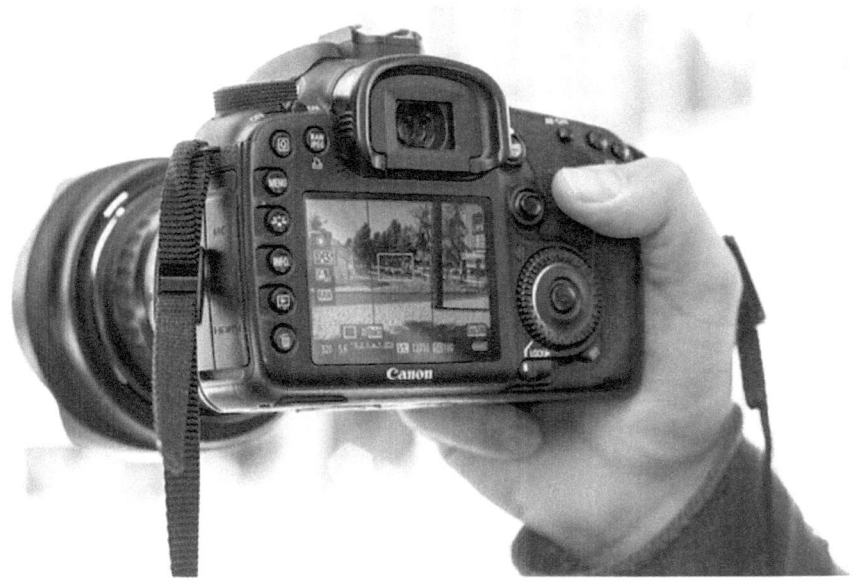

If you're a beginner and you feel unsure of how to get the best out of your DSLR camera then this guide is for you. It is not intended to replace your manual, but to help you gain the confidence to switch off the automatic setting and take full control of your DSLR camera.

Here's to your success!

Let's start at the very beginning.

Chapter 2: How to Choose the right DSLR Camera for YOU- Different Types of Cameras

For starters, what does the term DSLR mean? DSLR stands for Digital Single Lens Reflex. This refers to a camera with one lens and a mirror which reflects the light with a digital imaging sensor that records to a card instead of a photographic film.

Nowadays, there is an abundance of DSLR cameras to choose from and it can be intimidating to unravel the information overload on the world wide web. Since its introduction in the late 90s, the DSLR camera has become the choice for serious amateurs and professional photographers. It offers awesome image quality, interchangeable lenses, tons of creative controls and it can perform more tricks than a well-trained chimpanzee from Gibraltar!

What do you need to consider before buying your entry-level DSLR camera? Do you choose a brand rich in photographic history and heritage? Do you choose one from a company that designed your microwave or your flat screen TV? Here are some important factors to think about before rushing out and making your purchase:

1. What is your budget?

DSLR cameras range from affordable to pricey and professional. Set yourself a budget for your purchase early on in your research and keep in mind some other costs you will need to consider:

Memory Cards: Some models are kitted out with the DSLR camera but may not be adequate in size. You might want to upgrade to at least a 1gb card.

Lenses: Some bundle deals include a lens kit but depending on your needs, you may want to upgrade.

Batteries: All camera models come with one but if you plan on traveling or doing several hours of shooting at a time, you might need to purchase a spare.

Filters: You might want a UV filter to protect your lens from scratches and dust or experiment with some creative projects later in your photographic journey.

Camera Bag: Some DSLR models come with a camera bag, but they aren't always the best quality. Your DSLR needs protecting, so invest in a quality bag.

2. What will you use it for?

What type of photography do you want to do? Are you buying a camera for general use? Are you planning on traveling with it? Are you going to use it for Macro Photography? Sports Photography? Wildlife Photography? Make a list of the types of photography you plan to use your camera for.

3. **Are there any other camera and lens options in that system?**

 Explore the other cameras and lens options that are currently available. You may find that one system provides you with more lenses and camera bodies to use once you become more advanced as a photographer.

4. **Do you plan on taking video as well as stills?**

 If you're a budding videographer or vlogger, then there are plenty of DSLR cameras that will suit your needs. Look for models that excel in focusing during video recording. Models that offer microphone inputs are essential. The Nikon D5600 and Canon EOS 200D both have this feature.

5. **What other features do you want?**

 Here are some common features that may or may not be important to you:

 LCD Size: It's surprising the difference a half inch can make when looking at your photos on your camera's LCD screen! Some people use the viewfinder at this stage of framing shots, but a larger screen can be a bonus.

 Maximum Shutter-Speed: If you are keen on action shots or sports photography, then you will want a DSLR that can handle a wide range of speeds.

Anti-Shake: Anti-Shake technology has been gaining popularity. Image stabilization that's built into the camera body is the coolest thing out!

ISO Settings: Most DSLR models offer a good range of ISO settings, but some have an even wider range, which is useful for low light photography.

Connectivity: Uploading your precious images to your computer or printer normally occurs via USB, but some people prefer FireWire or a Wireless system.

Flash: Professional DSLR models do not offer a built-in flash, but a hot-shoe. However, entry-level DSLRs will include a built-in flash system.

Burst Mode: Modern DSLR cameras allow you to shoot a burst of images quickly by holding down the shutter release. This feature is great for action and sports photographers. Note that DSLRs vary in the number of frames they can shoot per second and how many images they can shoot in a single burst.

Dust Protection: Image sensor dust protection is another feature that is gaining fans. In some models, this extends to self-cleaning for image sensors.

Semi-Auto Modes: Just as with 'point and shoot' cameras, several DSLR models are equipped with an impressive display of shooting modes including macro, night and portrait. Higher-end DSLRs don't normally have them.

What about DSLR bundles?

If you're purchasing your first DSLR, it might be easier to buy it as a kit. Normally, the kit includes the camera body as well as a standard 18-55mm lens. This lens covers a broad range (more details in chapter 4), but this is only the start. The great thing about having a kit is that you can add to it with additional lenses and other accessories in accordance with your photographic needs. Both Canon and Nikon offer the largest range of DSLR lenses, however, Pentax and Sony have a decent offering as well. Remember, you are not limited to one brand of lenses. I love the Sigma range of high quality lenses and Tamron and Tokina also offer high quality at lower prices.

Which DSLR is right for YOU?

Here are some DSLR camera recommendations:

Canon EOS 400D (Digital Rebel Xti)

This was my entry-level DSLR camera and I fell in love with it at first sight (it was a deep red- from the German market). It's an impressive camera that comes in a kit with an 18-55mm lens, a 10.1-megapixel sensor, a 2.5-inch LCD screen and all the features you will need to switch into manual and semi-manual modes. It boasts an integrated image sensor vibrating cleaning system and is portable and light, making it a good travel option. This camera is easy to use and a great starter for anyone nervous about stepping out of the 'point and shoot' comfort zone.

Nikon D3400

The Nikon D3400 is a reasonably priced entry-level DSLR that is popular among beginners. It features a whopping 24.2 megapixels, a 3-inch LCD screen and boasts a continuous shooting speed of 5fps! In addition, its "SnapBridge" Bluetooth connectivity transfers images directly to your smart device, making it easier to share your images on Facebook, Instagram and other social media sites. The Nikon D3400 has a clever "Guide Mode," which is a useful learning tool that offers real-time explanations of important camera features.

Pentax K-70

The Pentax K-70 is a great value DSLR camera. Its rugged looks and weather-resistant body makes it great for the outdoors. It has 24.2 megapixels and a 3-inch tilting LCD screen and features a full HD 1080p video resolution system. Image stabilization is built into the camera itself rather than the lens, which allows you to benefit from this technology with all mounted lenses. It's not the lightest of models, but if you want to discard your gym pass, this baby will work your muscles!

Canon EOS Rebel T6i (Called Canon EOS 750D outside the US)

The Canon EOS Rebel T6i is a beautiful blend of first-rate ergonomics and a brilliant sensor. It boasts a 3-inch articulating touchscreen which is said to be the best on the market, 24.2 megapixels and a continuous shooting speed of 5fps. This is a capable entry-level camera.

Olympus OM-D E-M10 Mark iii

The Olympus OM-D E-M10 Mark iii has been described as a little powerhouse of a camera! It has 16.1 megapixels, a 3-inch tilt-angle display screen and records videos in 4K. It is a great alternative to an entry-level DSLR camera and sports a 5-axis image stabilization system and a decent electronic viewfinder. This powerful camera is not a toy!

Nikon D5600

The Nikon D5600 is a trendy and feature-packed DSLR that takes awesome 24.2-megapixel images. What sets this gorgeous baby apart from the rest of the DSLRs is its 3.2-inch LCD that resembles a smartphone screen. You can pinch, zoom and set focus with your fingers. It's also great for "selfies" as you can point the screen in the same direction as the lens. When it comes to connectivity, the Nikon D5600 uses the SnapBridge app, so you can share your photos directly to your phone or tablet. Also worthy of mentioning here is it takes full HD 1080p video at 60 frames per second. It doesn't just look good, it also performs!

Canon Rebel SL2

If you are looking to spend a little more on your DSLR, then look no further than the Canon Rebel SL2. It's compact and lighter than most DSLRs. It has a powerful 24.2-megapixel CMOS sensor, boasting fast and accurate auto-focus and phase-detection. It has built-in WiFi and Bluetooth, making it easier for you to connect and upload your images. Another attractive feature is its

articulating touchscreen that can be flipped up or down to get shots from various angles. It also allows you to easily access and leap through different features.

Pentax K-S2

Most DSLRs offer an impressive full HD 1080p video. The Pentax K-S2 takes things a step further by offering 4K video and 1080p h.264 HD video! This DSLR provides outstanding video capture and comes with a full weather-resistant body and lens (over 100 weather seals across the whole camera), that ensure it's protected if you live in a rainy, damp or snowy country like me (Ireland). Its vari-angled 3-inch LCD screen provides great visibility outdoors. Outdoor and landscape photographers will love this DSLR camera that can withstand the toughest of weather conditions to produce unforgettable images.

Sony Alpha A68

The Sony Alpha A68 is a great camera for action photography. It's lighter, so you can take pictures faster, making it ideal for sporting events or nature photography. The camera speed is balanced by an impressive 79-point auto-focus that optimizes the shot straight away. It features a 24.2 APS-C sensor, full HD video recording and even has OLED display. This DSLR may be lighter but it is hard-wearing and has a solid textured build.

Canon EOS Rebel T7i

Are you thinking of creating your own blog or Vlog? The Canon EOS Rebel

T7i can handle all sorts of lighting situations and is perfect for recording adventures far and wide. The WiFi connectivity allows you to upload your footage to the web and its high ISO range (100 to 25,600) is expandable to 51,200, providing you with an extensive range of filming environments. It has a 24.2-megapixel APS-C sensor and can capture great DHR movies with full HD video. Its 3-inch vari-angle touchscreen allows you to quickly navigate the menus and settings. This DSLR can capture beautiful colors in demanding photographic conditions.

Hopefully this list has been helpful in assisting you to make an informed decision regarding your DSLR camera requirements.

Chapter 3: Camera Overview

To give you a better idea of how to effectively use your DSLR camera and get the most out of it, this section provides a helpful guide of the main features and buttons on your camera. It can be intimidating to see all the buttons and dials on your DSLR. This section should soothe your nerves and give you the confidence you need to set out with your first DSLR camera. Depending on the make and model of your camera, some symbols might look slightly different, but you will get a general idea.

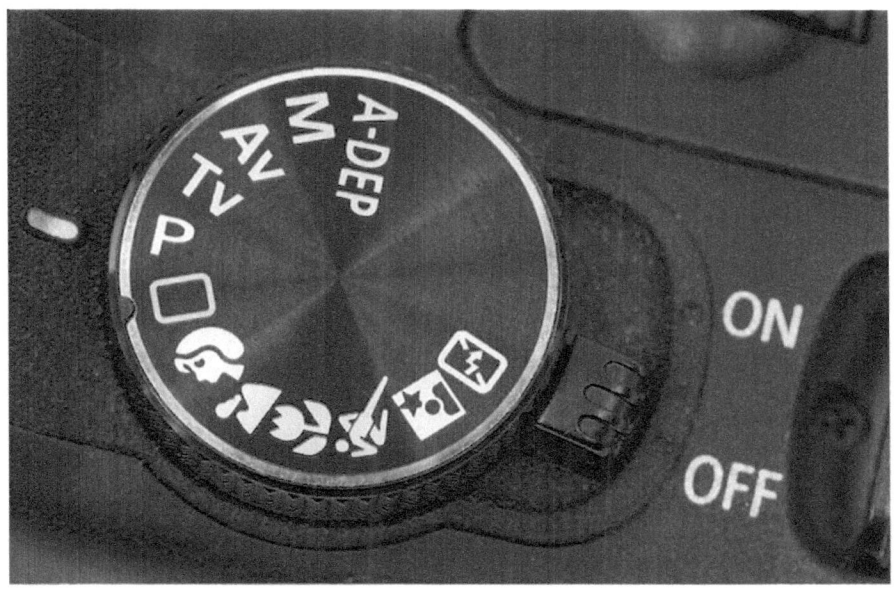

The DSLR Camera Mode Dial

Let's start with the camera's mode dial as shown in the above photograph. Most digital cameras come with a variety of modes for different situations. While most 'point and shoot' cameras focus on automatic mode settings, DSLRs feature modes that are a subtle mix of automatic and manual controls.

There are four main modes on the majority of DSLRs:

1. **(P) Program**
2. **(Tv) or (S) Shutter-Priority**
3. **(Av) or (A) Aperture-Priority**
4. **(M) Manual**

(P) Program Mode

If you select Program Mode, your camera will automatically choose the correct aperture and shutter speed for you. For example, if you point the camera toward a bright area, the aperture will automatically increase in number and keep the shutter speed reasonably fast. Pointing the camera at a darker area will result in the aperture decreasing to sustain a reasonably fast shutter speed. However, if there is not enough light, the lens aperture will remain at the lowest number (maximum aperture) with the shutter speed, decreasing until it reaches the correct exposure. Program Mode is what you use when you want to snap a quick "point and shoot" photo.

(Tv) or (S) The Shutter-Priority Mode

In Shutter-Priority Mode, you manually set your camera's shutter speed and it will automatically pick the correct aperture for you, calculated from the amount of light that passes through the lens. Shutter-Priority Mode should be used when you need to freeze or blur movement. If too much light is passing through, your camera will increase the lens aperture, which will decrease the amount of light passing through the lens. However, if there is not sufficient light, your camera will decrease the aperture to the lowest number, allowing more light to filter through the lens. This means that in Shutter-Priority Mode, the shutter speed stays the same (whatever you have set it to), while the aperture automatically increases and decreases depending on the amount of light. It's important to note that there is no control over subject isolation because you are allowing your camera to control the depth of field. (Subject isolation allows you to have an image where your subject is in focus, but the background is out of focus. This is a common creative technique used by many photographers).

(AV) or (A) Aperture-Priority Mode

In Aperture-Priority Mode, you manually set the lens aperture and your camera will do the honors of picking out the right shutter speed so the image is properly exposed. In this case, you have full control over subject isolation and can play around with the depth of field. This is because you can increase or decrease the lens aperture and let your camera do the work of measuring the right shutter speed. If there is too much light, your camera will automatically increase the shutter speed, but if you're in low

light conditions, your camera will cleverly decrease the shutter speed.

Therefore, unlike the other modes, Aperture Priority Mode has almost no risk of underexposure or overexposure because the shutter speed can decrease as low as 30 seconds and as fast as 1/4000-1/8000th of a second (depending on camera model). This is more than ample for the majority of lighting situations you will come across on your photographic adventure.

This mode tends to be popular with photographers because of the ability to have full control of the depth of field and the knowledge that the image will be correctly exposed under normal circumstances. The metering system in DSLRs works well, so let your camera do the calculations and control the shutter speed for you.

(M) Manual Mode

I suppose Manual Mode is self-explanatory. In Manual Mode, you can manually adjust the aperture and the shutter speed to any value. You have full control over exposure settings. You would normally use Manual Mode in extreme lighting situations where your camera has a tough time working out the correct exposure. For example, if you are photographing a particularly bright scene, your camera might guess the wrong exposure and either overexpose or underexpose the rest of your image. In cases like these, you can set your camera to Manual Mode and then assess the amount of light and override the exposure with your own settings.

Manual Mode is practical for gaining consistency in images, in case you might need both the shutter speed and aperture to stay the same over multiple exposures. For example, if you want to stitch together a panorama, all the shots you need would need to have the same shutter speed and aperture. Otherwise, some of the images would be darker and others lighter, or worse. Once you set the shutter speed and aperture to the values of your choice in Manual Mode, your images will have consistent quality.

Generally, Manual Mode is used in extreme conditions.

What about the other pretty symbols on the camera mode dial?

Many entry-level and semi-professional cameras have other pretty symbols printed on them such as "landscape," "portrait," "sports" and "macro" depending on the model and camera. (Note that professional cameras do not have these modes). Here are a few things to note about these custom modes:

***They are combinations of the above four modes and some camera specific settings.

***If you get used to using these custom-made settings, you could get lost if you must change camera brands as different cameras have different custom modes, so it's best not to rely on these.

***Make it your goal to learn the four main camera modes discussed in this section and step up your photography skills!

I will now focus on the other main features of a DSLR camera and explain what each part does:

The Shutter Button

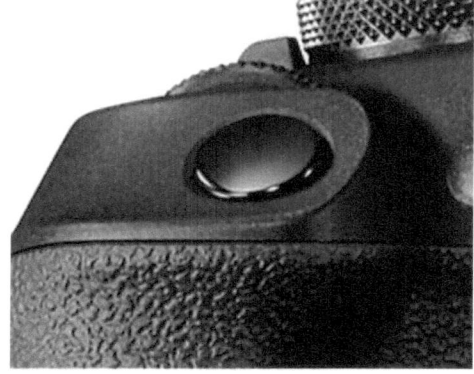

You will need to press this button to release the shutter. The shutter button press has two stages: (1) Half-pressing the button activates the AF function (Auto-focus) (2) Pressing it down fully releases the shutter.

Red Eye Reduction/Self Timer Lamp

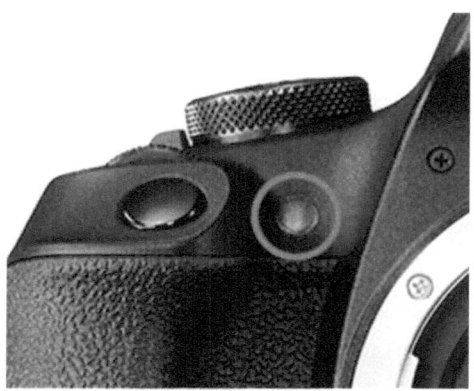

Red Eye Reduction is enabled on your DSLR camera. Half-pressing the shutter button will light up this lamp when you make use of the built-in flash. When you set the self-timer, this lamp will blink for the period of the timer until the image is taken.

Lens Mount

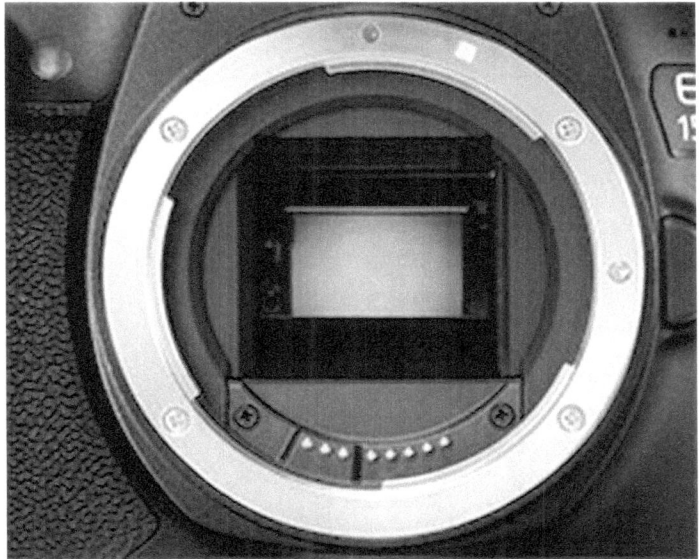

This is the part that connects your interchangeable lens to the main camera body. To attach your lens, line up the lens mount index (image shown below) on the lens with the corresponding one on the lens mount and then continue to turn the lens clockwise until you hear a click.

Lens Mount Index

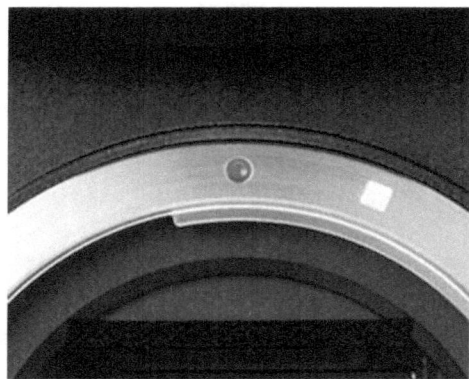

Line up the mark on your lens with this mark when you are either attaching or detaching a lens.

Lens Release Button

Press this button when you want to detach your lens. The lens lock retracts when the button is pressed, which will allow you to turn the lens freely. Before shooting, lock the lens into place by turning it until you hear that familiar click.

Eye Cup

The purpose of the eyecup is to prevent external light from entering when your eye is in contact with the eyepiece. A soft material is utilized to reduce friction on your eye and forehead.

Viewfinder Eye Piece

The viewfinder eyepiece is a small area on your camera that you look through to assist you in composing your photo and achieving focus on a subject. When you shoot using a viewfinder,

the external light is reduced. This allows you to fully concentrate on your subject and makes it easier to track moving subjects.

Menu Button

If you press this button, it will display the menu and allow you to adjust camera functions. After you select a menu item, you can adjust the camera setting in more detail.

Playback Button

Use this button to playback images you have captured on the LCD monitor of your camera.

Access Lamp-Set Button/Multi-Controller

This lamp will blink when there is data transmission between your DSLR camera and the memory card. While this is blinking, do not open the card slot or battery compartment cover as doing this could cause the camera to malfunction.

ISO Speed Setting Button

Press this button to adjust the light sensitivity of your camera.

Focus Point Selection Button

Use this button to go into the AF point (auto-focus) selection mode while AF shooting. You can then select any of the AF points manually by using the Multi-Controller keys.

Display Button

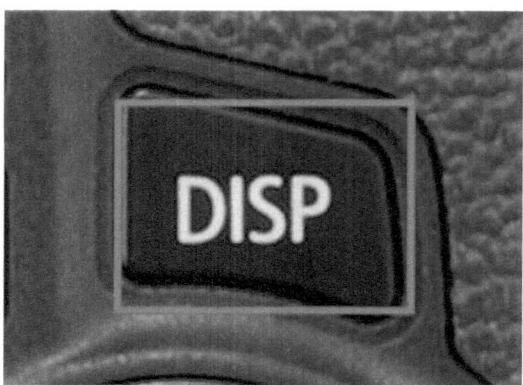

Chapter 3: Camera Overview

The DISP button can do several things:

1. Turn the display on/off

2. Toggle between different information displays in Image/Movie Playback mode and while Live View shooting

3. Display your camera's main function settings when the menu is displayed

Live View Shooting/Movie Shooting Switch

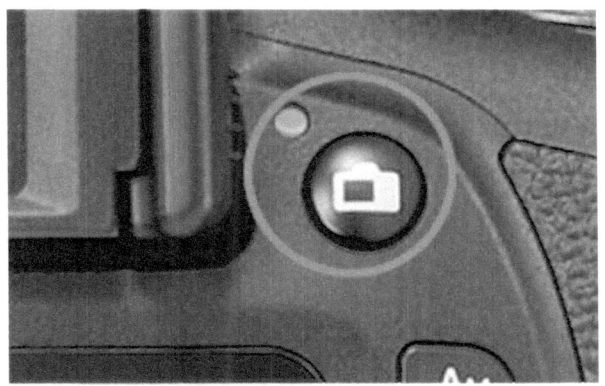

You can use this button to turn on/off the Live View function. If you press the button once, it will display the Live View image on your camera's LCD monitor and your camera will be ready for Live View shooting. If you want to record a movie, set the shooting mode to "Movie Shooting" on the mode dial and press this button to enable recording. To stop, just press the button again.

Erase Button

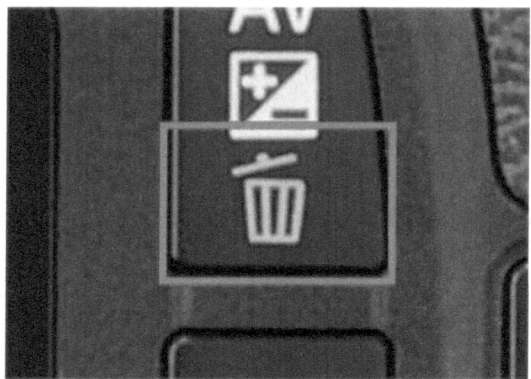

Use this button to delete unwanted images.

Dioptric Adjustment Knob

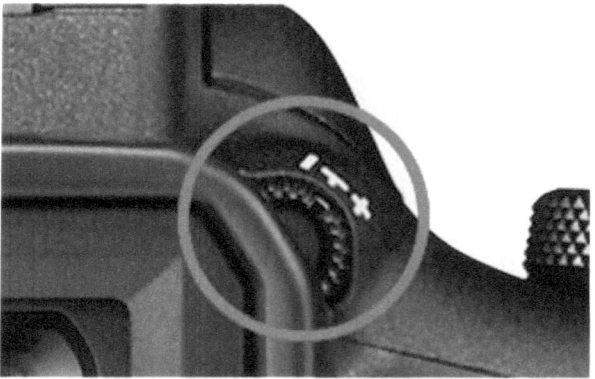

If you need to adjust the clarity of the viewfinder image for your unique eyesight needs, this is the knob you will use. Turn the knob while looking through the viewfinder to adjust the view.

Shots Remaining

This section on your LCD screen indicates the number of remaining shots you can take. This number will vary according to the capacity of the memory card and the image-recording quality you select.

ISO Speed

This area on your LCD screen indicates the ISO speed. A higher ISO speed makes it easier to capture shots in low light areas. In the ISO Auto setting, your camera will automatically choose the best ISO setting for the scene. You can also choose to set the ISO speed manually. You'll find more about ISO speed in chapter 6 of this guide.

Aperture Value

This area on your LCD screen indicates the aperture value. A smaller value means the aperture is wider, which allows more light to be captured. The aperture value is known as an "f-number." You can read more about aperture values in chapter 6 of this guide.

Focus Mode Switch

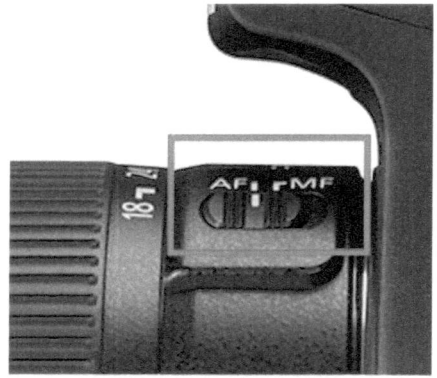

You'll use this switch to set the focus mode to either Automatic (AF) or Manual (MF)

Speaker

The audio of a recorded movie can be played back through the speaker. While enabling movie playback, turning the Main Dial will allow you to adjust the volume to the desired level.

Hot Shoe

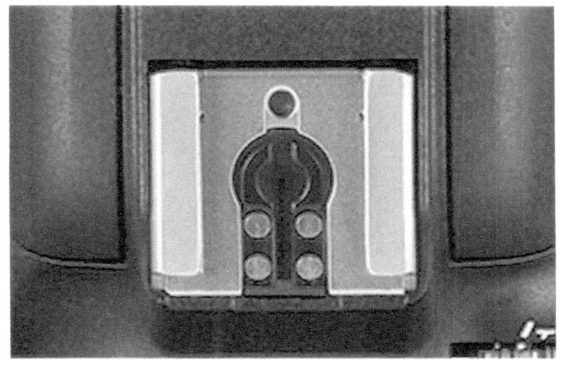

This is the terminal where can you attach an external flash unit to your DSLR camera. Data is transmitted between your camera and the flash unit through the contacts. Therefore, it's important to keep the contacts clean so the external flash fires properly.

Flash Button

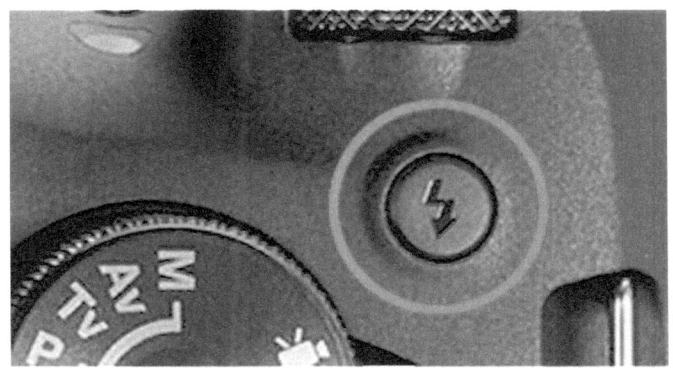

Use this button to enable the built-in flash to "pop up." Depending on what mode you are in, the built-in flash may pop up automatically.

Main Dial

The main dial has a multi-purpose function and allows you to perform various tasks such as adjust the value of shooting settings (like aperture/shutter speed/exposure) and scroll through playback images.

Zoom Ring

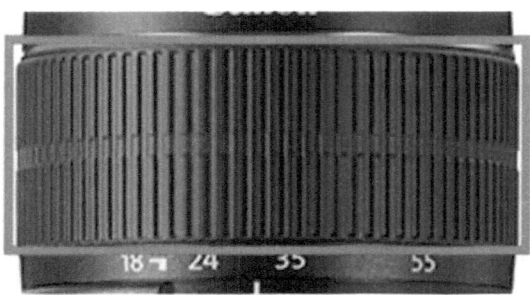

To change the focal length, you will need to turn the zoom ring. The selected focal length can be identified from the numbers and index marks at the lower end of the lens.

Focus Ring

When your camera is in the Manual Focus (MF) mode, turn this ring to adjust the focus. Note that the position of the focus ring varies according to the lens you are using.

Remote Control Terminal

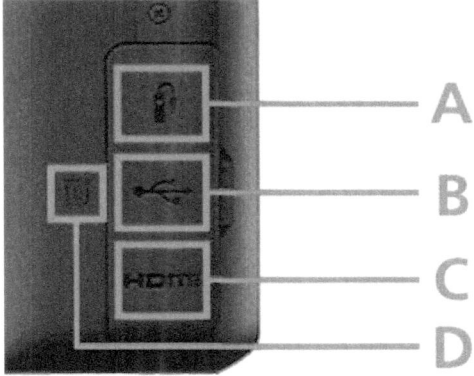

A: Remote Control Terminal

The Remote Control Terminal is used for connecting your camera to an external device. Before you do so, make sure the device is compatible with your camera.

B: Audio/Video OUT/Digital Terminal

C: HDMI mini OUT Terminal

These terminals are for TV output, data transmission and HDMI mini output.

D: N-Mark

If the N-Mark contacts an NFC-compatible smartphone, pairing between your camera and the smartphone will be initiated.

Card Slot, Battery Compartment, and Tripod Socket

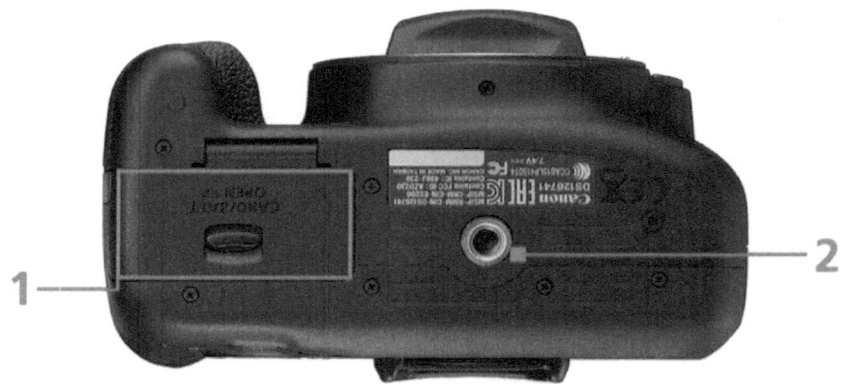

1. **Battery Compartment**

 This is the where you will load the battery for your camera.

2. **Card Slot**

 Your memory card for recording images goes here.

3. **Tripod Socket**

 This socket located at the rear end of your camera is what you will use to attach your DSLR to a tripod.

 That's it, folks! These are the main parts of your DSLR camera and how they function. Give yourself a pat on the shoulder for getting this far. Now let's look at lenses.

Chapter 4: Types of Lenses

Don't know your telephoto lens from your macro lens? Wondering how to bring more creativity into your photography by using a 'fish-eye' lens? Read on to discover the different lens types.

The lens is the most important part of the camera, so it's important to know your unique photographic requirements. The type of lens you use will be crucial in capturing that perfect shot. What works for one person may not work for another. Here are the types of lenses and the best ones for each photography type:

Standard Lens

A standard lens allows you to capture an image that represents a similar perspective and scale to what the human eye sees. It captures images as you see them and doesn't distort or change the

size of an object. A standard lens comes with a 35mm-80mm focal length.

Prime Lens

A prime lens only offers one focal length, such as 35mm or 50mm. The focal length is fixed and cannot be changed. Although this might sound limiting, the prime lens offers higher optical quality as it only needs to be optimized for one specific focal length. This makes a prime lens ideal for shooting fast-moving subjects, as they have a faster aperture (for a more detailed explanation of aperture see chapter 6). They also perform well in low light conditions, producing a crisp image.

Wide-Angle Lens

A wide-angle lens allows you to capture shots with an extra wide perspective. It has a much shorter focal length of 10-42mm when compared to a standard lens. A wide-angle lens enables you to shoot the complete setting without missing out on important elements in the image. These are popular with outdoor photographers who enjoy capturing landscapes.

Zoom Lens

A zoom lens has much to offer. Due to its ability to provide focal lengths between 24mm-70mm, it gives you the versatility to quickly and easily alter your composition without the need to reposition yourself.

Telephoto Lens

Telephoto lenses are popular for wildlife, sports and documentary type photography. They have long focal lengths between 100mm-800mm that allow you to capture your subject(s) from hundreds of meters away. These lenses make your subject seem larger and closer to you than they really are. For example, if you take an image of a lion on safari, a telephoto lens can make it appear as though it is right in front of your nose, when in reality it's far enough away for you to avoid being eaten!

Fish-Eye Lens

As its name suggests, a fish-eye lens makes every image you take look like it was shot from a goldfish bowl. A fish-eye lens can produce wide-angled images and can sometimes create circular, convex or oval images by warping the perspective and creating a 180-degree image. If you enjoy creative photography, this is a great lens for creating interesting and unique photos.

Macro Lens

A macro lens is designed for close-up photography. If you love photographing butterflies, bees and small insects, this is the lens for you. Many cameras come with a "macro" setting on the dial, but the beauty of a macro lens is that it allows you to get extremely close to the subject you are shooting and produce life-size images.

In summary, here are our recommendations for the best lenses for each photography type:

Photography Type	Best Lens To Use
Landscape	Wide Angle Lens
Portrait	Prime Lens
Travel	Prime Lens For People Scenes & Fish-Eye Lens For Artsy Effects
Street	Prime Lens
Sports & Weddings	Prime Lens
Wildlife	Telephoto Lens
Everyday Shots	Standard Lens
Insects, Flowers & Food	Macro Lens

Remember that the lens you use will influence the outcome of your photographs. Get to know your photography requirements and the kind of photos you would like to shoot before you start looking for a lens.

Chapter 5: Camera Filters

Camera filters are used for various reasons. They can help you capture scenery in difficult lighting conditions, protect your camera lens, intensify colors and reduce reflections. Some landscape photographers rely on them every day for work, while others like street or portrait photographers may never use them.

Photography is primarily about the quality and intensity of light, which means it's often important to alter the light before it enters the lens by means of a filter.

Think about it. Why do you wear sunglasses (apart from looking cool)? They help you see better in bright lights, reduce glare and protect your delicate eyes from the harmful effects of UV rays, wind and dust. Filters serve a similar purpose for your camera.

Types of Lens Filters

Camera filters are produced in various shapes and forms but the most popular lens filters are the circular, screw-on filters. These can be attached directly to the filter thread in front of a lens. Their size depends on the lens filter thread, but the standard and most common size of these screw-on filters is 77mm.

Circular Screw-On Filters

Examples of circular screw-on filters include UV/Clear/Haze filters, color filters, neutral density and circular polarizers. These come in different thicknesses. The thicker examples add vignetting and the thinner types reduce or cut out vignetting.

Square Filters

Square filters can be held in place by a filter holder which is directly attached to the lens filter thread. These can hold multiple filters. The most common size for DSLR cameras is 4x4. Square filters are a popular choice for landscape and other photography.

Rectangular Filters

These are fitted just like the square filters via a filter holder system. However, in contrast to the square filters, they have more room to move up and down and are the main choice for landscape photography. The most popular size for rectangular filters is 4x6.

Drop-In Filters

Drop-in filters are used inside long telephoto lenses. It's interesting to note that only clear and polarizing filters are used for drop-in filters.

Specific Filters Explained

UV/Clear/Haze Filters

In the past, the main purpose of the UV/clear/haze filter was to block ultraviolet light (UV) and infrared light (IR) from hitting the film. However, today these filters are used to protect the front element of the lens from dust, grime and spray. Thankfully, all modern digital camera sensors are built with UV/IR filters, so they are no longer required for that purpose. Many photographers invest in these filters to protect their lenses, so they don't have to repair an expensive scratch or broken lens element.

Neutral Density Filters

The function of a Neutral Density Filter is to reduce the amount of light that reaches your camera. In so doing, the shutter speed is decreased and the exposure time is increased. These filters are particularly useful in the daytime when the light cannot be sufficiently reduced by turning down the lens aperture and decreasing ISO (more on aperture and ISO in chapter 6).

Neutral Density Filters come into their own when the need for motion blur is required. These filters blur the movement of people and flowing water by enabling you to lower your shutter speed while controlling the depth of field based on the ND filtration you place before your lens.

This type of filter is used in any setting where you need to use larger apertures (with a flash) and/or slow shutter speeds in bright conditions.

Polarizing Filters

Polarizing filters change the way your camera sees and deals with light. This filter reduces the amount of reflected light passing through your camera's sensors. The result will be skies that appear deeper blue, less glare and reflections off water and reduced contrast between land and sky. This means polarizing filters are perfect for outdoor and landscape photographers.

There are two types of polarizing filters- linear and circular. **Please be aware that linear polarizers should not be used on**

DSLR cameras as they can cause metering errors. Circular polarizers are ideal for DSLR users due to their construction.

ND Graduated Filters

An ND Graduated filter is a slot-in filter, with the top half appearing like sunglasses and the bottom half appearing clear. The top half decreases the amount of light entering the lens and the bottom half captures the darker areas of your scene normally.

These filters can be bought in sets of three at different stop levels (1, 2 and 3) and the gradation between the two parts of the filter can be soft (a gentle gradation) or hard (a more sudden gradation).

As the ND Graduated Filter is a slot-in filter, you will need to purchase an attachment for the end of your lens that will hold the filter in place.

What are the differences between ND Graduated and Neutral Density Filters?

While the ND Graduated Filter is normally used to even out scenes with extreme exposure variations on opposite sides of the frame and is clear on one end, gradually building up density toward the other end, Neutral Density Filters are level and even from edge to edge in their degree of density.

Here is a cheat sheet for specific lens filters and their uses:

Lens Filter	Photography Type	Purpose
Uv/Clear/Haze Filter	Any	Protects Front Element Of A Lens From Dust, Grime, Moisture & Scratches
Polarizing Filter	Any	Filters Out Polarized Light, Intensifies Colors, Increases Contrast & Reduces Reflections
Nd Graduated Filter	Landscape Photography	Darken Or Tint The Top Or Bottom Portion (Left & Right) Of A Frame Leaving The Opposite Side Untouched. Can Add Element Of Drama To Ordinary Photograph
Neutral Density Filter	Landscapes & Flash Photography	Reduces Light Entering Lens, Decreases Shutter Speed, Creates Blur Effect, Large Aperture Used With Flash To Prevent Overexposure

Chapter 6: Taking a Photograph

By now you must have almost "given up the ghost" in your eagerness to start taking photos with your DSLR camera. No worries, the time has finally arrived. The center stage is yours!

The following tips will help you improve your skills in the world of photography. Remember, photography is an art and as with any art, you never stop learning. The best way to improve is to practice. If you can, take photos every day and don't be afraid to make mistakes. This is all part of the learning process. Try to be open to learning from others whether they are accomplished photographers or beginners in the craft.

***Learn to hold Camera correctly

This might sound basic, but many beginner photographers don't hold their cameras properly, which can lead to camera shakes and disappointing blurry images. Since you won't be using a tripod unless you're shooting in low light conditions, it's vital to hold your camera in such a way as to avoid the mishap of blurred, zoned-out images that look like they've been shot in space.

With time, you'll develop your own way of holding your camera, however, you should always hold it with both hands. Firmly grip the right side of your camera with your right hand, then put your left hand beneath the lens to support the weight of the camera.

You'll find that the closer you keep your camera to your body, the more stable your hold on it will be. In case you need more stability, you can lean against a wall or get down on your knees. Try to adopt whatever position is necessary to give you the steadiness you need.

***Learn the Exposure Triangle

This section might sound boring and you might want to skip it, but please resist the urge to close your eyes and fall asleep! Once you've mastered these three vital elements of exposure (aperture, ISO and shutter speed), you will bag yourself sharp, well-lit images.

Aperture

Aperture is the opening of your lens and determines the amount of light that gets through to your camera. In addition, it controls the depth of field. Depth of field refers to the area that surrounds the focal point of an image which remains sharp. A wider aperture (shown by a lower "f-number") allows more light through, but has a narrow depth of field. A narrow aperture (shown by a higher "f-number") allows less light through but has a wider depth of field. A wide aperture is great when your intention is to isolate your subject while keeping the whole scene in focus, such as in a group shot. In this case, you'll need a narrow aperture.

ISO

The ISO controls your camera's sensitivity to light. A low ISO setting implies your camera will be less sensitive to light, whereas using a higher ISO makes it more sensitive to light. As the ISO increases, you will notice that the image quality decreases, and you might notice "noise" or a grainy element to your images. An ISO setting of 100–200 is generally ideal when shooting outdoors during the day, but when shooting in low light conditions such as at night or indoors, a higher ISO of 400–800 or higher might be necessary.

Shutter Speed

The shutter speed determines the duration of time the shutter remains open when you take a photograph. The longer the shutter stays open, the greater amount of light gets through to your camera's sensor. This means a fast shutter speed is great for freezing action shots and a long shutter speed will blur motion. Long shutter speeds can produce some interesting and creative effects, but this requires the assistance of a sturdy tripod.

You might find the table below useful:

Shutter Speed 1/1000 1/500 1/250 1/125 1/60 1/30 1/15 1/8 1/2 1

APERTURE	f/22	f/16	f/11	f/8	f/5.6	f/4	f/2.8

ISO	100	200	400	800	1600	3200	6400	12800

Less Light More Light

*****A Wide Aperture**

When you are shooting portraits, be it of people or animals, your subject should be the principal focus of the image. The best way to achieve this is by using a wider aperture. This will ensure that your subject is kept in sharp focus and will blur out any distracting background.

It's good to remember that a smaller "f number" reflects a wider aperture, and the wider the aperture, the more spectacular the effect will be. Some camera lenses can reach as low as f/1.2, however, even apertures of f/5.6 can do this. Play around with this feature to understand more about how the aperture affects your photographs. Also, switch to "AV" or "A" Aperture-Priority Mode and experiment by taking shots with various apertures.

***A Narrow Aperture

If you are interested in landscape photography, you will need a different approach,*** because everything in the foreground and background should be in sharp focus. In this case, you'll need a narrow aperture rather than a wide one.

Since a larger "f number" translates to a narrower aperture, try f/22 or higher if your lens will allow for it. Once again, experiment using the "AV" or "A" Aperture Priority Mode so you don't have to stress about setting up the shutter speed each time.

***Worried About Using A High Iso?

Many photographers avoid shooting with a high ISO setting. They're afraid of noise spoiling their "street credentials," but there is a time and a place for everything!

If you find yourself unable to lower your shutter speed because of motion blur and a tripod isn't present, it's better to capture a sharp photograph with a little bit of noise than to come away empty handed. Thankfully, all is not lost due to the saving grace of some awesome photo editing software that is readily available on the internet. (More about that in chapter 8). Camera technology has advanced to such an extent that it's possible to produce amazing looking images even with ISO settings of 1600-6400 or higher.

To minimize the effects of noise when shooting at a higher ISO setting, it's generally a good idea to utilize a wider aperture when possible. Even slightly overexposing your images can be a great help, as when you are editing your images with a software system, making light areas darker won't increase noise, but making dark areas lighter will.

***Learn How to Use the White Balance

The white balance assists you in capturing colors more accurately and is responsible for the general warmth of an image. If you fail to adjust the white balance, your photographs may take on a blue, orange or green hue.

The white balance can be sorted in an editing software system, but it can be a nightmare if you have a lot of images to adjust. It's best to get it correct on the camera. There are standard white balance settings on your camera which might include Tungsten, Daylight, Fluorescent and Automatic White Balance. Note that the automatic white balance may not always do a good job with your images, so it's best to change the settings that fit the light situation you are shooting under.

***The Histogram

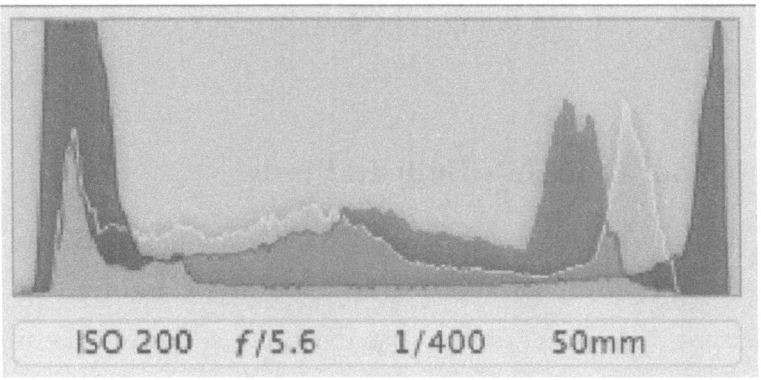

Believe it or not, the histogram is not just a bunch of pretty colors on the screen. Learning to read the histogram correctly will take time and practice but it will help you judge the exposure of an image. You can take a glance at your camera's LCD screen to see if you've exposed an image properly, but this isn't always an accurate gauge, as an image can appear darker or brighter on the screen than it really is. This is where the histogram is important; it's the most accurate way to check the exposure of your image.

The histogram provides you with information about the tonal area found in your photograph. The left side of the graph is made up of the blacks or shadows and the right side shows the whites or highlights.

If the graph is slanting towards the right, this means your image may be overexposed and you will have lost much detail in the lighter areas of the image. If it's slanting to the left, it's probably underexposed and will be too dark. Generally speaking, a graph spread across the box with a centrally placed "mountain" is a "perfect" neutral exposure. Depending on the type of photography you are doing, you may have to tweak things with editing software.

Using Your Camera's Built-In Flash

The built-in flash on your DSLR camera is a cool and convenient feature, but if you're not careful it could lead to some unpleasant effects. When you use the built-in flash at night or in low light conditions, you may notice harsh shadows or the "red-eye effect" in your subjects. In these cases, it's better to increase the ISO settings and have some noise in your images than use the onboard flash and run the risk of ruining the shot altogether.

However, if you find yourself in a situation where there is not enough light, leaving you little option but to use the built-in flash, do not despair. Here are three steps to try before shooting the photograph:

Step One: Go to your camera's menu and find the flash settings. Reduce the brightness as much as possible.

Step Two: Try diffusing the light from the flash by fastening a piece of paper or opaque scotch tape over the flash. This can soften the light.

Step Three: Try bouncing the light off the ceiling. This can be accomplished by holding a piece of white cardboard in front of it at an angle.

Try these ideas out and be amazed at how your images improve!

Understanding the "Rule Of Thirds"

Let me assure you, the Rule of Thirds is not complicated. Believe me! It's perhaps one of the first rules on composition a photographer will come across. It's simple and it works.

The general idea of the Rule of Thirds is that images are more interesting and balanced when they are not centered.

Close your eyes and imagine a grid with two vertical lines and two horizontal lines that divide your photograph into nine equal sections. If you were applying the Rule of Thirds, rather than placing your important elements or your subject in the center of your photograph, you would try and position them along the points where the grid lines intersect. On some DSLR models, you can turn on a grid option, which can be useful if you are still learning about image composition.

The Rule of Thirds is good to learn but you may sometimes choose to break the rule in the fight for creativity and personal expression. That's fine, but before breaking this rule, it's important to understand it! It's also useful to develop the habit of being aware of the points of interest and where you wish to place them.

Using a Tripod

When you invest in your first tripod, pay attention to its weight, stability and height. Its weight is important as you will be carrying the tripod with you and you don't want to be dragging around the weight of your grandfather's clock on your shoulders! However, you will need something that is stable and not too light as it will need to support the weight of your camera and lens.

Why invest in a tripod? If you want to capture sharp and professional photos in low light conditions without increasing the ISO too much, then a tripod will be a vital part of your photographic gear. With a tripod, you will be able to experiment with long exposure photography (this is when you leave the shutter open for seconds or even minutes). This can make for some fascinating effects when photographing waterfalls, rivers or cityscapes. For motion-blur or time-lapse photography, using a tripod is a must.

Get Things into Perspective

Now we're on a roll with experimenting and being creative. Playing around with perspective will give you an edge in your photography. It's amazing to see how different a particular scene can look when approached from different angles, whether from above or below. It can change the whole atmosphere of the image.

When shooting animals or children, try to get down to their level and view the world through their eyes. If you are shooting a portrait, try standing on a step ladder or bench and shoot your subject from above. Not every angle will work for every image, but without experimenting you will never know!

What's In a Background?

It's good practice to pay close attention to the background of your shot. In general, the background should be as free of clutter as possible; you don't want your viewer's attention to be distracted from your main subject due to a busy background. Try to keep your background neutral and simple.

If you find that the background is too overpowering, move your subject or change your angle. If this doesn't improve things, it can be possible to blur the background by using a wider aperture and getting as close to your subject as possible. However, a neutral background works best, especially if you are positioning your subject off to the side and the background is very visible.

Here are a couple more tips to improve your photography skills:

Portrait Photography: Keep Eyes In Focus

The eyes are an important facial feature and are typically the first thing people look at. This is especially true for close-ups or headshots. Therefore, your subject's eyes should be your main focus point. To achieve a sharp and clear image of both eyes, choose a single focus point and direct it at one of the eyes. As soon as the first eye is in focus, keep the shutter button pressed halfway down and move the camera a bit to recompose the image and include the second eye.

The Great Outdoors: Shoot In the Early Morning and Evening

Lighting is everything and it can make or break an image. Early morning and evening are the best times of the day for taking photographs. In photography, the "golden hour" is the hour just after the sun rises or before it sets. This is because the sun is lower in the sky and its light is softer and warmer.

If you shoot landscapes, still-life or portraits, making use of the early morning or evening light can give your images a tranquil feel, with added warmth and glow, in addition to the long shadows cast by the time of day. The "golden hours" are not the only time you can get good outdoor photographs, but it sure does make things easier for you!

When You Feel More Confident: Start Shooting Raw

You may have heard the professionals referring to shooting RAW images. RAW is a file format like JPEG, however, unlike JPEG it captures all the image data recorded by your DSLR camera's sensor rather than compressing it. When you shoot in RAW, you will not only achieve higher quality images, you will also have far more control in post-processing. For example, you will be able to easily correct issues with over/under exposure and modify color temperature, contrast or white balance.

The downside to shooting RAW is that the files take up considerable space. Also, RAW images always need post-

processing, which means you will need to invest in photo editing software (more about photo editing software in section 8).

However, shooting RAW can transform the quality of your photographs. If you have the necessary time and space available, it's a route worth taking. If you are unsure how to switch from JPEG to RAW, just check your DSLR camera's Bible- I mean- manual for a detailed explanation!

Chapter 7: Storing Your Photographs

When digital photography first arrived on the scene, storage space was a problem. Now there are many options for storing your photographs. Computers, memory cards, external hard drives and free software offer plenty of storage capacity with the added convenience of keeping photographs all in one place. We're spoiled now! Let's consider a few options:

YOUR COMPUTER. Downloading your images onto the internal hard drive of your computer is an easy way of storing your photographs so they're readily available to you. However, I recommend to keep a backup folder of your pictures in the event of a crash or theft of your computer.

MEMORY CARDS. Modern memory cards can store more than 100GB (1 gigabyte= 1,000 megabytes) worth of images. The average card stores between 16-32GB and can be purchased on or offline without hurting your bank balance. You may find that your DSLR camera's memory card offers ample storage space.

EXTERNAL HARD DRIVE. The price of these gadgets has steeply decreased over the years. You can find external hard drives for less than $40 (£30) with a capacity of 160GB. You can use a USB cable to connect them to your computer. Then you simply drag and drop images from your image folder to the external hard drive. Because an external drive is lightweight and small, you can give it to family or friends who wish to make copies of your photographs. An external drive is a great way to

store your images, especially if you keep it somewhere safe, away from your main computer.

USB STICKS. This is an inexpensive way to store your images. A USB stick can store around 10GB worth of files. Simply remove the cap and insert the end into the USB slot on your computer or laptop. Then drag and drop the images you want to store on the USB stick onto its icon which will appear on your system's desktop. This is yet another great, cost-effective way to store a select group of your images and transport them easily.

ONLINE STORAGE. If you don't fancy any of the above options and your computer is heaving under the burden of "megabytes" pressure, there are many free online services where you can store your cherished photographs. The most popular of these photo-sharing sites are Flickr, Shutterfly and Photobucket. You can also keep your photos on Facebook. You will need to read the small print for these sites, as they all offer a certain amount of photo storage for free, but some may put limits on the amount you can upload each month and levy a fee if you exceed it. The benefit of these sites is that your images will be available for others to view and comment on.

If you're not fussed about getting feedback and need more storage space, or just a safe back-up for your images, an online file storage site could suit your needs. Personally, I use Dropbox and find the service easy and convenient. However, websites like Mozy, Box.net and Amazon S3 offer a considerable amount of

free storage space. Signing up for a free account with any of these sites is a simple affair.

<u>Here is one more tip</u>: Microsoft has its own online file storage under the "Windows Live" software umbrella: Windows SkyDrive. SkyDrive is free and you can sign up by clicking the SkyDrive link at the top on the "Windows Live" main page.

Image Backup Tips for Beginners

Photographs often hold precious memories and have sentimental value. A fire, flood or disaster could rob us of passing on those memories to future generations. Therefore, it's a good idea to always have safe copies of your most important photographs.

As discussed, having your images on an external hard drive is ideal but an accidental fire could cause major damage. It's a good idea to have another copy outside your home, perhaps at your workplace, stored at a parent's place or with friends. Online storage comes into its own here as you can access your photos from anywhere with an internet connection.

It makes sense to have your photographs organized like your work files. It's a good idea to have consistent folder structure and naming methods for easy identification and backing-up.

Try to get into the habit of regularly backing up your images. Once a week is ideal; that way you can keep a track of which images are backed up and which are still waiting. If you use the editing software "Lightroom" to manage and organize your

images, you will find options on "import" that will enable you to automatically make a backup copy to a predetermined location.

You may feel that having 3-4 copies of your photographs borders on the edge of paranoia. It won't be an easy task updating all these sources, but reflecting on the importance of your family, business and hobby photographs will assist you in taking the necessary steps to avoid a mishap.

Chapter 8: Editing Your Photographs

At some point, you will want to invest in photo editing software. The point of this software is not to edit your images beyond recognition, but to enhance them, tweak them and bring out their best.

Once you start shooting RAW, post-processing becomes necessary. You will need photo editing software that can do the basics such as crop, remove spots and blemishes and adjust exposure, white balance and contrast. Before you know it, you will be performing better tricks than a Viennese trained circus elephant!

Most professional photographers swear by Adobe Photoshop or Lightroom.

Other photographers are happy to start with a less expensive program such as Photoshop Elements or PaintShop Pro. Let's briefly consider the pros and cons of six of the software editing systems available:

Adobe Photoshop

Adobe Photoshop is the King & Queen of all photo editing software. You can achieve practically any effect you wish with Photoshop. It's super creative, super flexible and super everything! It has loads of tools to get the job done. In addition, it can do a host of things other software cannot, like stitch panoramic images, HDR, 3D rendering, head swapping, video editing, work with Vector graphics and more. However, there's a steep learning curve. It's not for beginners. There is no "guided tour" or "start here" and no handy presets. Photoshop is a tool for the intermediate to advanced image editor. There is also a monthly subscription fee to consider. If you're not prepared to commit to the cost or time spent learning how to use the program, Photoshop is not a good fit for you.

Lightroom

I enjoy using Lightroom editing software and have no issues about paying the small fee. That said, it should be noted that Lightroom is more suited to the intermediate photo editor. If you are a beginner or want to keep things simple, Lightroom will not be the best choice. It enables high-quality image editing and has one of the best RAW processors around. It also works well with

other software as plugins. It comes loaded with lots of presets, so you can save anything you might do more than once as a preset (or predetermined group of settings). This is handy for quick photo editing. There are free presets and more available for purchase.

Aside from the software being challenging for beginners, the advanced creative controls are still limited with Lightroom. Also, the "catalog" concept used by Lightroom is difficult to grasp and set up at the beginning. Import and export are not intuitive or easy and can leave many guessing.

Photoshop Elements

Photoshop Elements is the little sister of Adobe Photoshop. It can do everything its big sister does, but comes with loads of help and guided editing. This program has been created with the beginner in mind and is easy to get started regardless of your experience or skill level. It is a good starter program for most photographers.

Photoshop Elements comes with a 30-day free trial and can be purchased outright or subscribed to for a monthly fee. It is both MAC and Windows friendly. The advantage of using Photoshop Elements is that it's training for the future. It's a good foundation to learn from before graduating to Photoshop or another advanced software.

Corel Paintshop Pro

Corel Paintshop Pro is an affordable and powerful photo editing software with organizing and sharing tools. It is the most widely known competitor to Adobe Elements with new enhancement tools such as Express Lab. This is a quick photo enhancement tool that you can apply to your images. Paintshop Pro has more pro-level tools and a streamlined workspace.

This software is a good mix of beginner friendly and advanced functionality. It provides many useful learning resources and features a user-friendly interface. Even the expert photographer can appreciate the tools Corel Paintshop Pro has to offer. It comes with a 30-day trial period. There is no possibility of a monthly subscription- it must be purchased outright.

Unfortunately, this photo editing software can only be used on the Windows operating system.

Affinity Photo

Affinity Photo software has a very similar interface as Photoshop. It's not easy to figure out what to do after uploading a photo. It does everything Photoshop does, but not as well. Like Photoshop, you need to invest plenty of time to learn how to use it. It comes with a 10-day trial. The biggest advantage of this photo editing software is the price. It's got the lowest price tag in this software level at under $50. This software is not suitable for the beginner photo editor.

GIMP

Gimp is a powerful FREE image manipulation program designed for photo editing, tweaking, animations and image creations. He's the red-headed stepchild of the photo editing world who found himself on the throne after forcing other editing software to move over! Don't be fooled by the name. Gimp is not a gimp but a powerhouse that runs smoothly on almost every platform. It can handle just about every format you could throw its way. It's a great alternative to Photoshop and is kept up to date with fixes and latest features. Gimp is a community developed software, which means that as a user, you can have a direct input. There is a learning curve, but not a steep one. It does not have an intuitive interface.

Chapter 9: Conclusion

You've made it! You have reached the conclusion of this DSLR photography guide for beginners. I know how tough it can be to learn the basic principles of photography and my goal was to present it in a fun and simple way.

I hope you enjoyed reading through this guide and that it has inspired you to get the most out of your DSLR camera.

Don't be afraid to experiment and remember, practice makes purr....fect!

HAPPY SHOOTING!

If you've enjoyed reading this book, subscribe* to my mailing list for exclusive content and sneak peaks of my future books.

Click the link below:

http://eepurl.com/dDUoFL

OR

Use the QR Code:

(*Must be 13 years or older to subscribe)

www.ingramcontent.com/pod-product-compliance
Lightning Source LLC
Chambersburg PA
CBHW020607220526
45463CB00006B/2485